Khamis Mushayt, Saudi Arabia 1984

James Willer PhD

Copyright © 2012 Author Name

All rights reserved.

DEDICATION

I worked on this project with a Navy SEAL. He made the whole experience worthwhile.

CONTENTS

	Acknowledgments	i
1	Background	1
2	Queen of Sheba	17
3	Hanging Village	20
4	Road to theRed Sea	23
5	Turkish Fort	32
6	Al Souda and Najran	37
7	The Palace	41

ACKNOWLEDGMENTS

.As part of their religion, there are three things they must do with a non-believer. He must convert, pay a tax, or be killed.

My company paid my tax without telling me

I would like to thank Saudi Arabia for not killing me.

It was a great adventure of biblical proportions.

and I learned a lot.

Prison
The one place I never went

1 BACKGROUND

My style of writing for this book will be in the form of general conversation. I am the author of this book but by no means a highly experienced professional writer. I realized a long time ago that I could not be perfect at everything that I attempted to do in life but it has never stopped me from trying new things. Some of my greatest life learning events have occurred when I failed to be perfect. This book may not be a perfect literary work worthy of the best seller list, but I guarantee it will contain interesting information for you.

Back in 1984 I had plane tickets in hand to go to Australia, but a job offer came up of greater interest. Armed with a new Master's degree in Exercise Physiology, I interviewed to work on a military research project in Saudi Arabia. I would be living in a town called Khamis Mushayt and working at an Air Force base nearby. The job was to analyze the physical fitness levels of the F-15 eagle pilots and recommend ways to improve their ability to fly the aircraft effectively. This story is not about the research project, details, or results of my effort. I did my job and got paid well for the work. The first thing I did when returning to the United States was pay cash for a Harley Davidson motorcycle, as life continued on. This book contains my memories and things I learned while living in a foreign country. I tried to make the most out of the opportunity by travel and study. The job

was interesting but in the bigger picture of things, the area history and culture were far more important to my life. By exposure to new things we learn both the good and the bad. I embraced it all. I shook hands with the most powerful people in the world at the time, and howled with the wild dogs. I left no opinion and no tracks, learning a great deal along the way.

In order to make it clear the piece of ground I'm standing on you have to go back in time to the biblical time of Abraham. This person mentioned in the bible had two children one by his wife and one by his slave or maid depending on which word you prefer to use. Isaac the son with the wife created the lineage Christianity, while Ishmael the other son with the slave or maid created the lineage Islam. Each religion has two main figureheads represented by Jesus and Mohammed. Both religions claim these individuals are the son of God and will return to Earth at some point.

Each religion also has a specific set of rules to live by. Within Christianity they have the Bible which contains everything related to that religion's rule set. In Islam they have the Koran, the Hadith, and Sharia law. The Hadith is the book that outlines and contains the life of Mohammed. The Bible contains the life of Jesus and outlines how he conducted himself. Sharia law is the governance of the Islamic religion or the religious rules of government and is different from the rule set for one's personal life in Christianity. Overtime both religions have evolved in form and opinion to determine how that religion is going to interact with modern problems. The changing world around us creates conflicts that need to be solved by religion thought. An example of this with Christianity would be a time back around 1905. Christianity felt that swimming was immoral and the religion helped to pass laws banning swimming. This is no longer the case in modern times. Most Christians no longer have a problem with public swimming.

The Christian religion also had a different point of view of a woman's place in the family one hundred years ago. This point of

view has evolved but is still conflicted within the subset churches of the religion, which form a generalization unit called Christianity. Both of the above religions have to deal with modern problems, modern technology, and a constantly evolving world of change. It is important for followers of a belief system not to carry a point of view which is in conflict with their core religious beliefs. Members go to their perspective religion elders for the answers and that provides guidelines for dealing with these modern issues.

To compare and contrast the two religions a little bit, there are rules of how to conduct your physical life and there are rules dealing with problems related to your spiritual life. Christianity has Ten Commandments such as thou shall not steal, and thou shall not kill. The word kill can be interpreted by individuals differently to mean that one should not murder. Islam has a similar code or set of commandments that appear on the surface to be the opposite of the biblical Ten Commandments. Where you are to show mercy in Christianity, it is to show no mercy in Islam as mercy is a sign of weakness. You are not to lie to people in Christianity but are required to lie to non-Muslims as long as it is in the best interest of Islam.

Christians look at the life and times of Jesus and say, "what would Jesus do," in another words, to follow the example of Jesus as a pattern for their life. This same thing occurs within Islam, as Mohammed's life is clearly laid out in the Hadith. An example would be it is recorded he had four wives and the youngest wife was nine years old. This fact would allow followers of the religion to have four wives and the youngest being nine years old. The Islam leaders will expand this by saying you can have four wives but you must treat all four wives equally and provide equally between those four wives. There is also talk of the first wife having a status above the following three wives of this system but I have heard variations on that subject. Wives are considered property as one pays for them upfront like a contractual purchase.

A woman's place is in the home barefoot and pregnant, this was a

Christian point of view from some years back. It is no longer held by some as how things should be, but within Islam, the male is clearly defined in the head of the home role and a woman's place as property is to serve her husband. Her status and position are dictated where it is a husband's job to remind her of that position. He is to beat her once a month with a short stick but never in the face whether she has done anything wrong or not. This is to ensure that she is reminded what her position is. My point is not to shock you but only to state what the core rules may not change with modern times. Societal opinions have changed and that is one of the main points I want to make. Whether you adhere to these rules as written or feel these rules no longer apply, both attitudes will modify behavior and the implementation of the religion.

Looking at some other rules, Christianity has dietary restrictions listed in the bible and rules that dictate how to and what you should eat. Christians choose to no longer follow these restrictions but there is nothing in the Bible that specifically said different leaving it open to personal opinion. An overlook of the religions members show both religions have basically three groups of individuals. There are individuals that adhere to the rules system as written, taking it literally. The second group know these rules exist but pick and choose which ones they want to believe in or follow. The last group are the ones that claim to be of that religion but make no effort to believe or follow any of the rules, feeling the old structure does not apply to modern times.

As an example of variation, let's touch on homosexuality and the modern church. The different organizations or subsets within Christianity, walk a fine line where they say it's acceptable. The religion churches have preachers who are homosexual and welcome homosexuals into the organization. There are churches within Christianity that absolutely do not participate in this lifestyle whatsoever and believe it is wrong. There is great diversity on the subject within the entire organization. The Bible is very clear as to its

point of view but whether you want to follow that rule literary is a personal choice. Literal application for the controversy does not fit modern times as populations made acceptance of the deviation a normal thing. This same population supplies money and growth to the church as incentive to accept opinion. Another point of view on this subject is to embrace the behavior yet denying it conflicts with the Christian rules. If you do not accept it then you are hateful, is a common used phrase. With Islam it is very simple, anyone who says they are homosexual, claims to be homosexual, or performs homosexual acts where somebody finds out; they are to receive immediate death. According to the religion rules it is claimed, there are no homosexuals living in Iran at this time due to adherence of the policy. In America, a number of homosexuals freely embrace the religion of Islam before they would ever embrace what they see as hateful Christianity. Sometimes logic and feelings are two different things.

In order to demonstration the effect of an individual's point of view, I will use the term Evangelical Christian for a literal interpretation of the bible. Evangelical Christian is one on the extreme right side of the religion as opposed to going all the way to the left side of the religion which would be to follow a church with a homosexual preacher. Islam has the same divisions of thought, they have the individuals that adhere to the religion as it is written and those people are called radical Islam or extreme Islam. The modern term does not fit as how can one be extreme by adherence to the religion as written. If you are a Muslim, a follower of Islam, it would be the true religion or evangelical Islam as a more correct term. To be a hypocrite is to not follow the rules yet claim you are of that religion. There are various believe systems around that can help with how you effectively rationalize beliefs and not follow the rules, yet still be considered part of that religion. This behavior is more extreme, hypocritical, and radical for Islam than following the code as written.

The reason I'm giving you this background is to help with that piece

of ground or point of view. As the book enters Saudi Arabia in the early 1980s, it will give you a point of view of why this country is the way it is. The people of the country come in many flavors, most are not aware of Christianity or they will have a different point of view of Israel than the majority of the world. This background will change how you view the Middle East country having very little change from the past or how it will evolve into the future. I am going to talk about how Saudi Arabia was in the 1980's not how it is as of this writing. I waited a long period of time before approaching this subject just due to the religious and world sensitivity on the subject. Because it is the foundation country of Islam, there are parts of the religion or should I say how the religion is viewed that is kept in the shadows. This is done for a reason and anyone who exposes these things to the light where people can evaluate and look at it clearly can be considered violating rules. There is hate that this sort of thing generates and I wanted to, as best I could, avoid it by using a separation of time.

 The reason for looking at a religion rule set becomes so important is the cause-and-effect resulting from implementation of these rules. Saudi Arabia became held in time for most of the country. Pockets of modernization put 20% of the country into a culture of very well off, and left 80% of the country never changing from a long ago past. The world oil economic environment was separated from a person growing a small patch of grain, plowing the field with an archaic wooden plow with a piece of tin being bent over the front edge. These people worked simple lives by taking the grain to a milling location where a camel walk in a circle providing the power needed to grind the grain into a powder. This grain powder was then taken home and made into bread which was baked in a stone oven. The experience of being there in the unchanged world was a life gift for me. I had the opportunity to visit a home when a family first got electricity. This allowed them to replace the type of sawdust icebox my father grew up using, with a refrigerator. Additionally they remain covered in their home in order to protect themselves from the small pieces of sun contained the glass called a light bulb. I was told this from the family

in their words and from their point of view. It was a world separated from the rich and powerful of the time.

Khamis Mushayt is located in the mountainous southwest part of Saudi Arabia east of Abha in the Asir province. The city population was around 35,000 at the time I was there. It is located on the flat desert region above the Red Sea at an elevation of 6700 feet. The town is primarily the support community for an Army and Airbase located nearby. Khamis Mushayt is on the old caravan trail used during biblical times to transfer goods and services from the Yemen area to the south and Israel to the north.

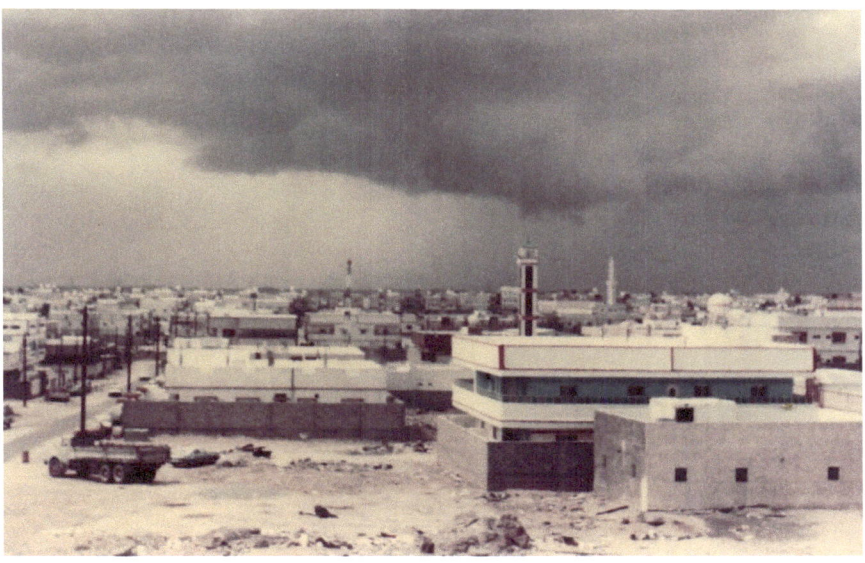

This picture was taken from the roof of my villa. A rain storm was coming in which created an unusual sky. Only a couple buildings downtown were over two stories tall. Homes had flat roofs with a raised edge alone with a wall surrounding the home. The tall spires you see are the call to prayer speaker system and mosque locations. Prayer is called five times during a 24 hour period. That black one in the center is loud. Especially at 3am.

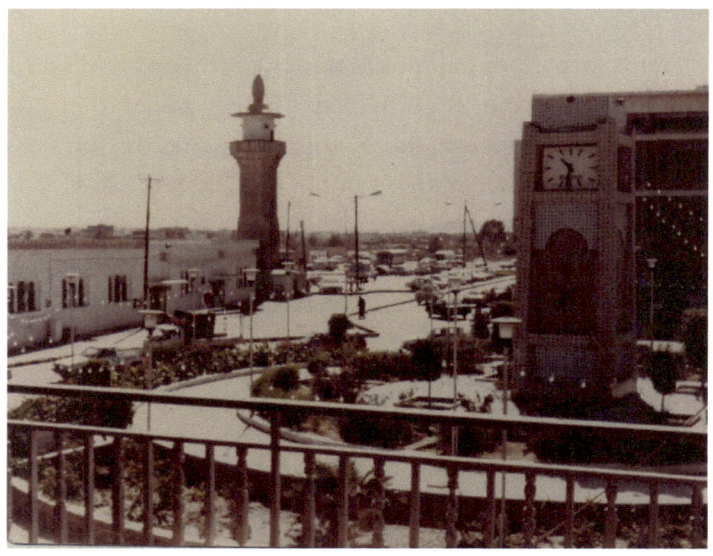

These pictures shows the center city mosque and the start of the downtown market

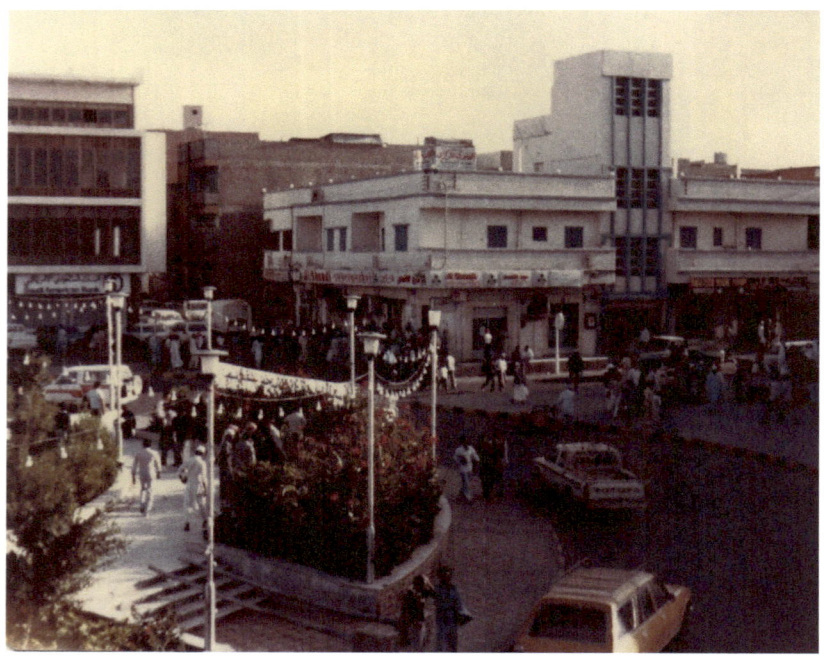

The term for market is souk. This location is the center of the city and the main market area. The traffic circle is the area of the Friday executions.

I was downtown on a Friday looking for some good food when the religious police started to round up all non-Saudis. There are two sets of police, the ones that handle things like traffic and minor events and the ones that enforce Sharia Law. We were formed into a crowd in the area located to the right side of the prior bottom picture. A black van drove up and several police with submachine guns got out. A man with a hood over his head was removed from the back of the van and placed on his knees. The leader of the group lectured on his violation of Sharia law. A second walked up behind him and shot him with automatic fire several times in the back of his head, never removing the hood. He was then drug back into the van. The doors closed and the van drove away. Everyone else went back to shopping. This type of event only happened on Friday and at this location so if you wanted to avoid seeing one just don't shop downtown on Friday. As a side note, Friday is the Islamic version of the Christian Sunday.

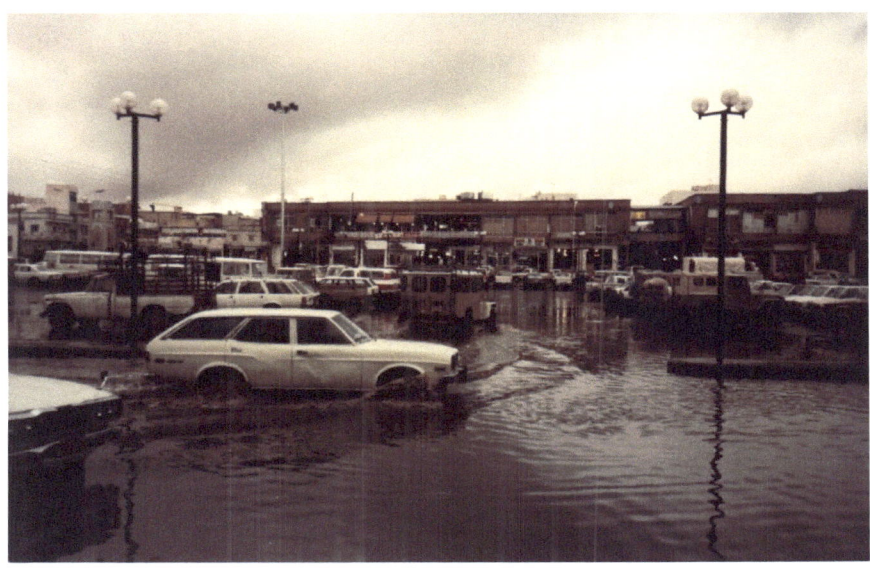

Only once or twice a year it will rain, thus a rain event is worth a picture or two. Notice the small Toyota pickups were a popular form of transportation and utility.

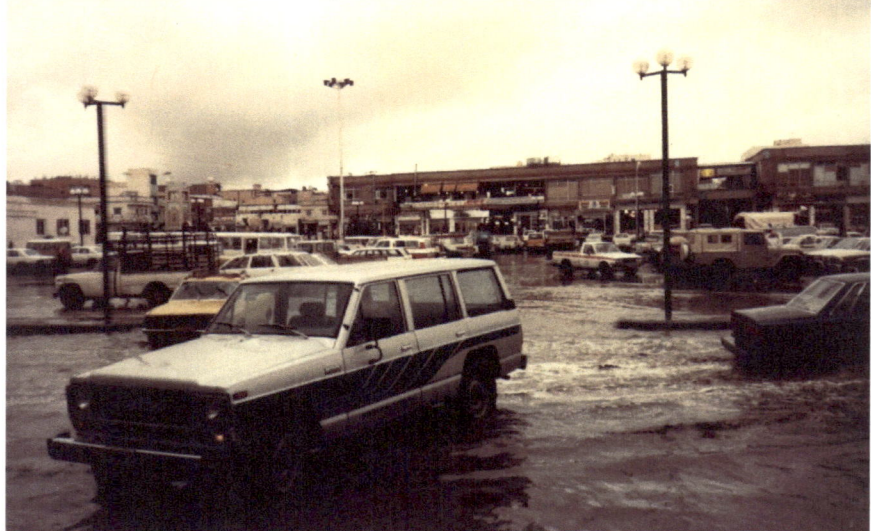

It you are into buildings, old buildings were made of dried mud and straw. This is the same bricking procedure mentioned in the bible. New buildings were made of concrete and steel. The market area contained both styles of buildings.

Khamis Mushayt 1984

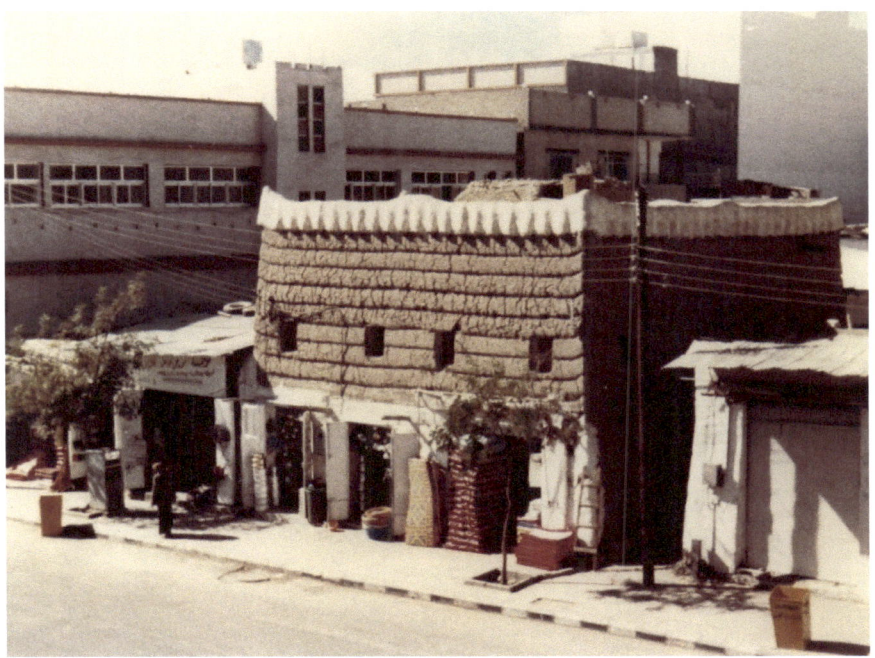

Gold was a good buy in this part of town. It was 22 carat and was weighted. It did not matter what form it came in or style. It was sold by the daily price of gold printed in the paper. The shop was wall to wall with gold chains and charms. Prayer was called and the owner left the shop unattended for a half-hour unlocked with you standing at the counter waiting for him to return. If you steal something, you get your hand cut off on Friday.

My favorite memory is of the food. Most of it was fresh and good quality and I do love to eat. I never had a problem with any food I ran across and I eat at the street venders a lot. My favorite street food was the layered meat and other stuff spinning on a shaft in front of a heater. You shave this off into a French bread roll. So good!

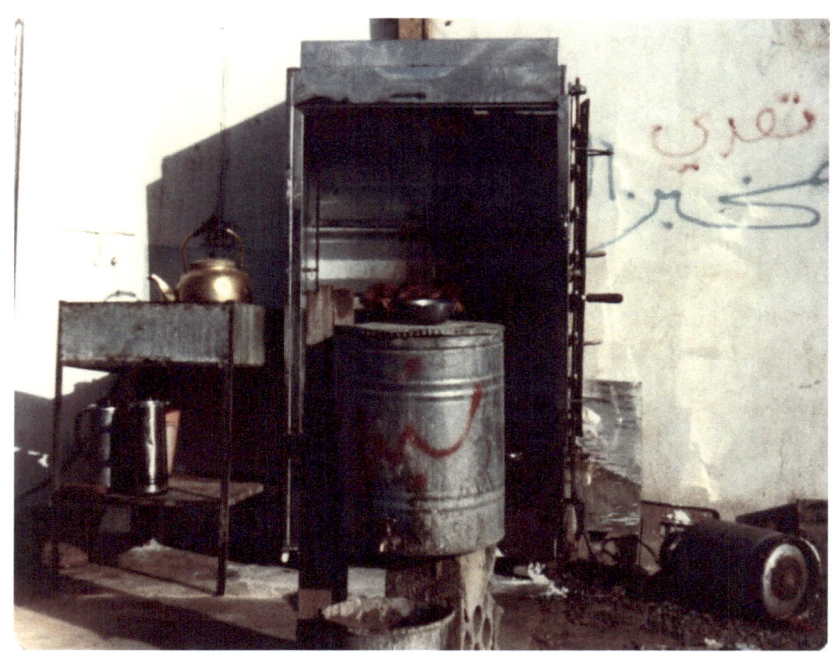

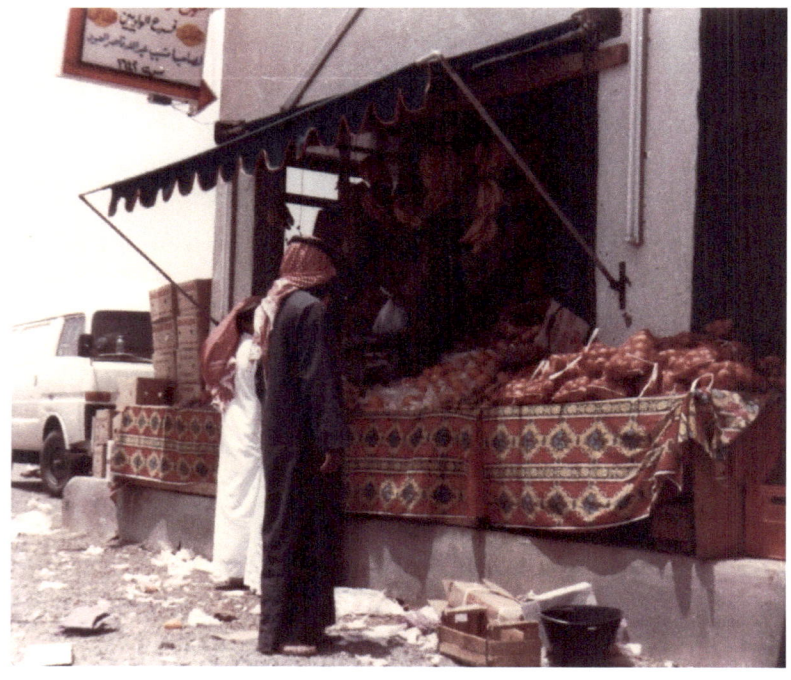

There was another market area on the edge of town that I liked to shop at. No one spoke English here as they did downtown. I did much better at bargaining once I was able to speak some Arabic.

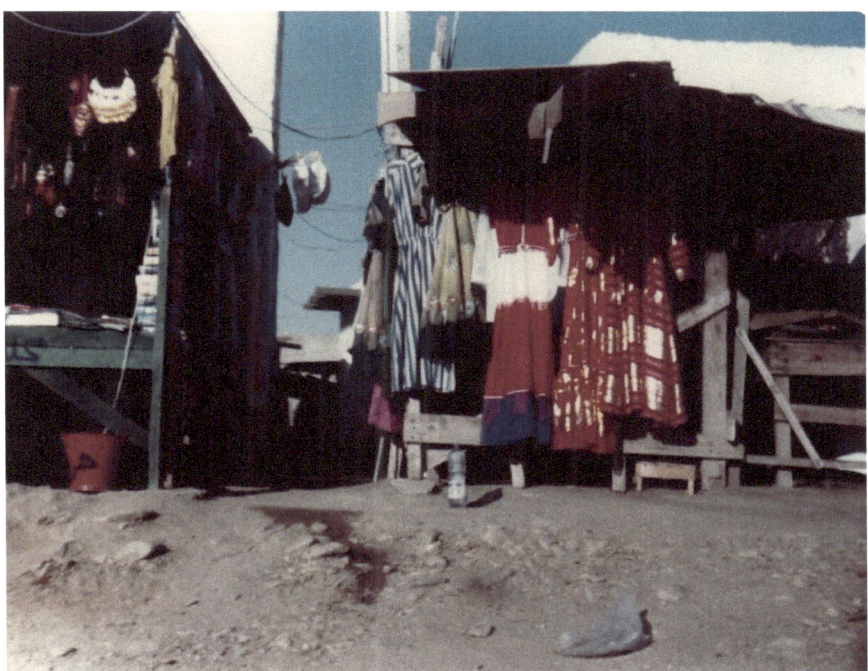

These next pictures are of daily life as it goes about the normal flow. Kids will be kids and we all are similar in so many ways.

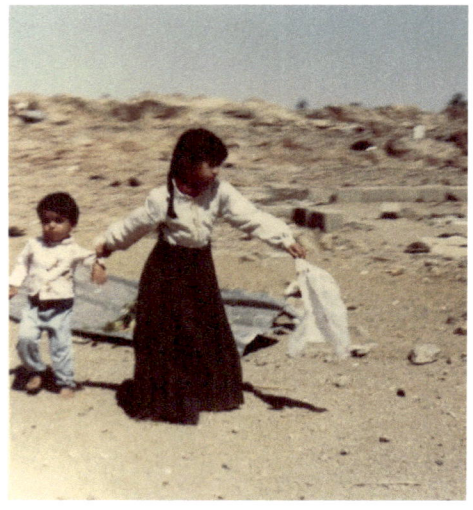

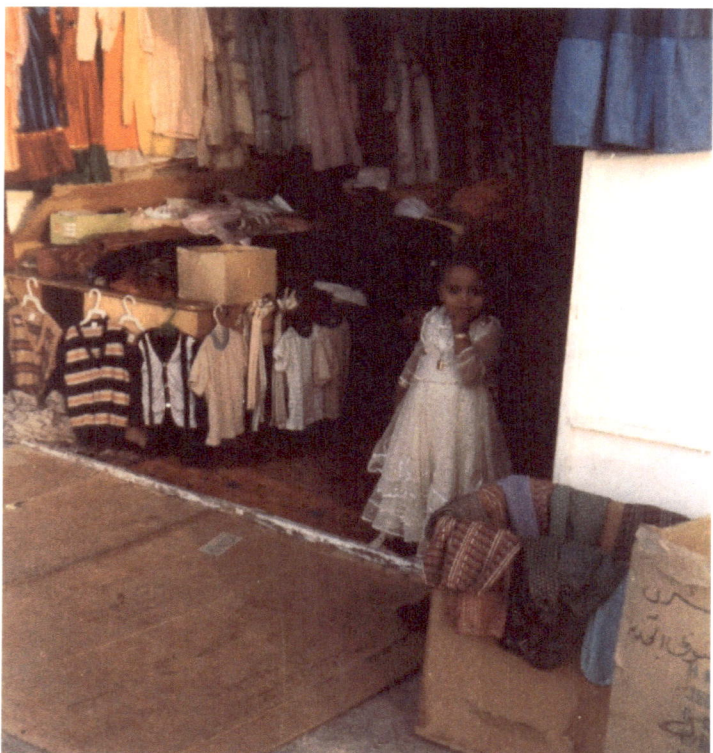

Khamis Mushayt 1984

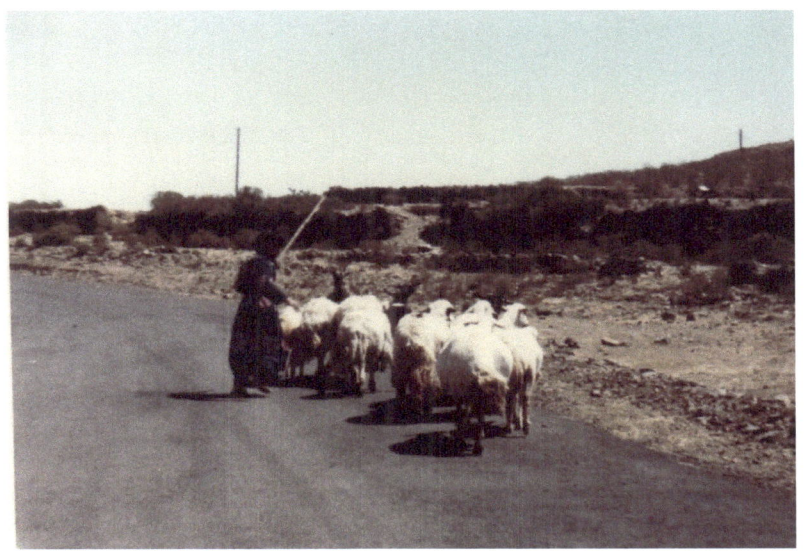

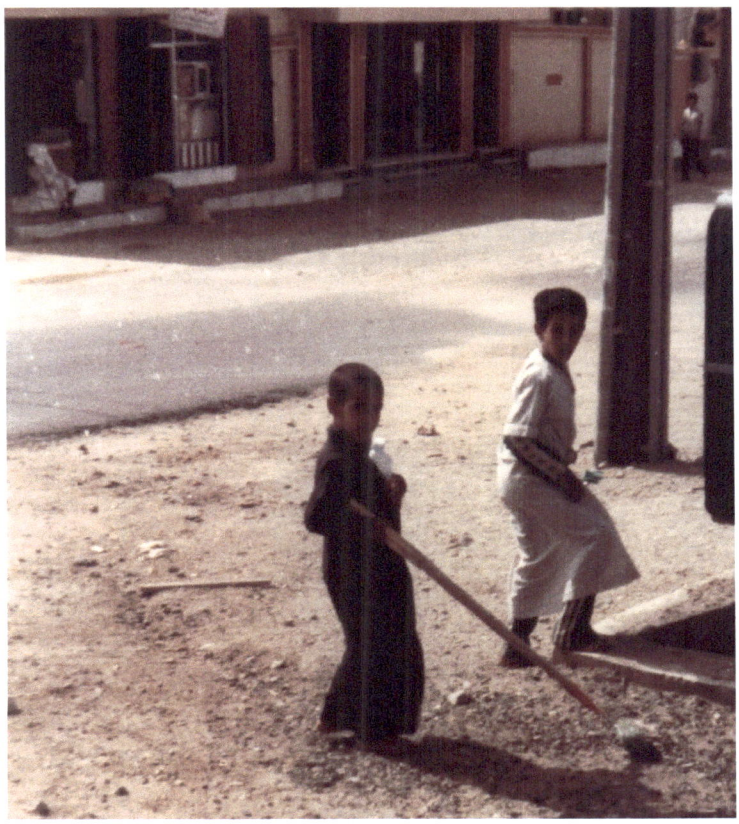

I took this picture because I thought it was so cool of a vehicle. I could see my father driving this down the streets of the small town I grew up in.

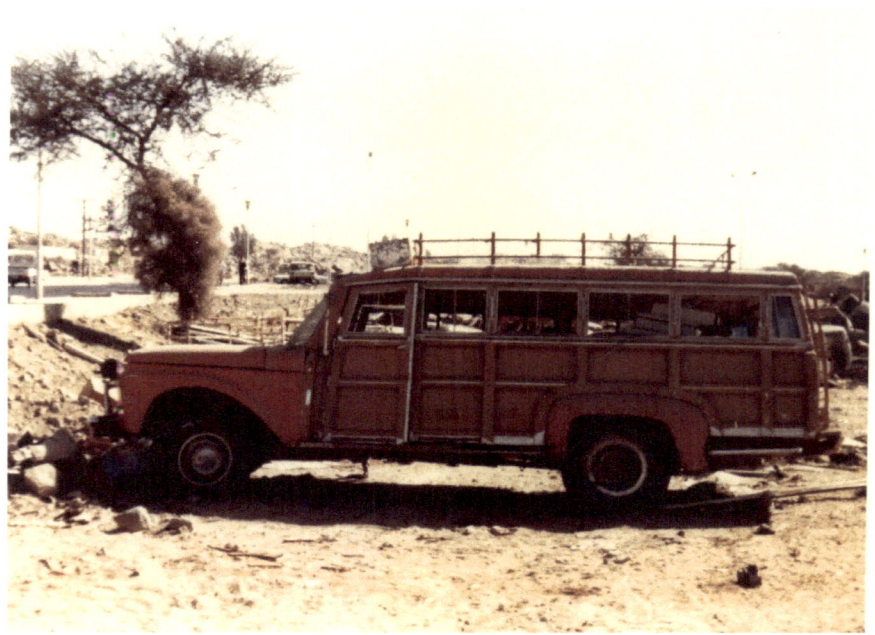

2 QUEEN OF SHEBA

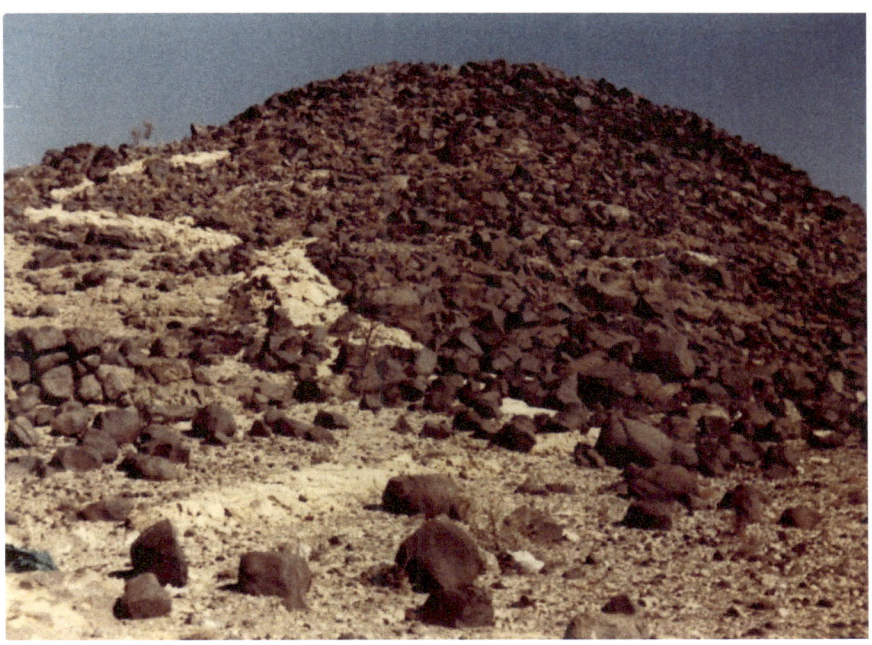

The Queen of Sheba mountain is located on the east edge of Khamis Mushayt. It is two kilometers from the front entrance to the local Army base. It is made of a black volcanic rock with a trail of white quarts up the south side. When the rocks are struck together they ping with a hollow tin type sound. From the top you can see the outlines of the old buildings. The Queen camped here on her way up to see King Solomon. The drawings at the top were dated to her time period.

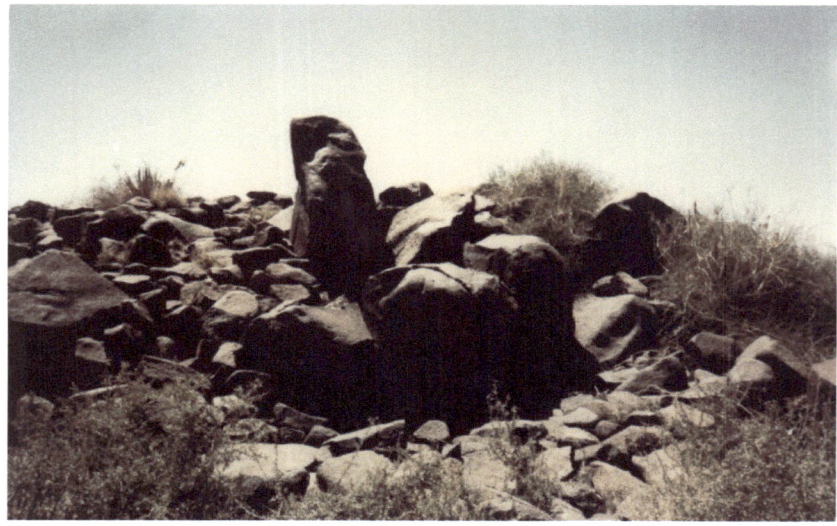

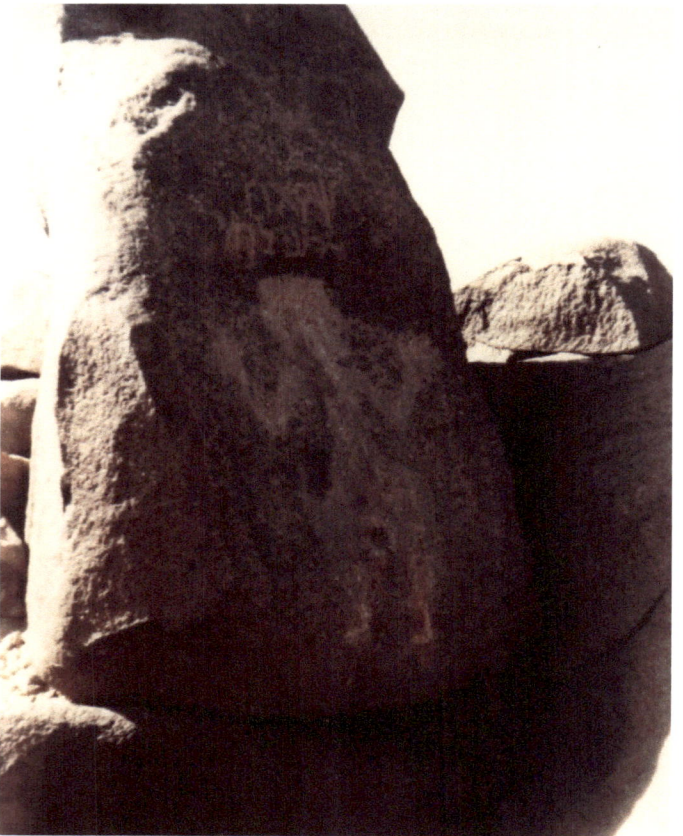

The above picture i[s]
the overview. I wa[s]
told that this is her
fertility symbol.

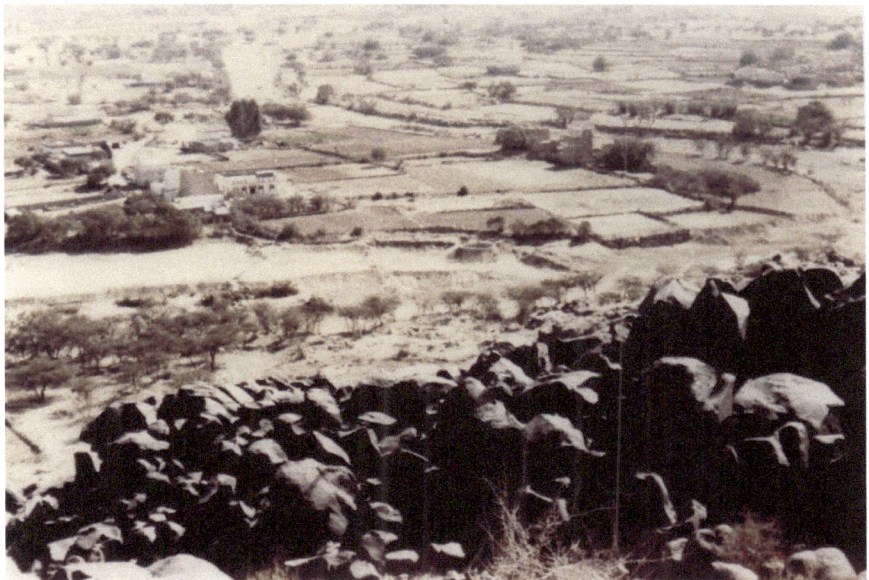

I wish I would have taken a better picture with my Kodak 110 camera. The building foundations are in the bottom left of the above picture. This area contained no signage, fence, or foot traffic. It is a place of no interest to the locals other than as a directional marker seen at great distance. Coming up from the south, up 6700 ft. to this flat area, the mountain would have been the perfect marker for a layover on the caravan trail.

3 HANGING VILLAGE

Hanging Village is located about 15 kilometers southeast of Khamis Mushayt. It is the closest thing to a tourist spot in Saudi. Located on the old caravan trail, it is the only way out of the deep valley moving south to north. From the valley floor there begins a steep climb for about ¾ of the way up terminating with a straight rock wall face. That is the point where the village is located, at the base of the wall. The valley is located on the upper left in the photo. Village is lower right.

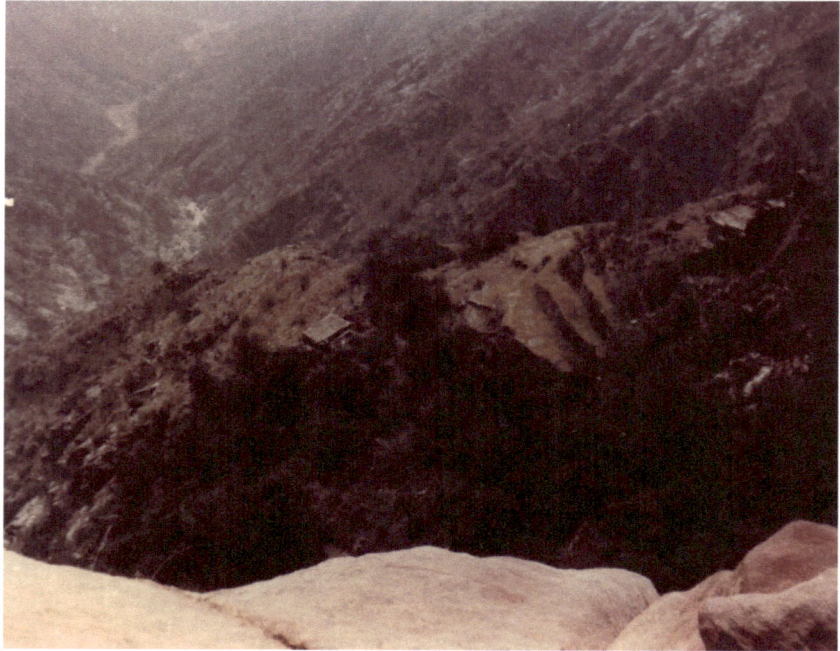

The government ordered the people to leave the village in the early 1970's because many old people were falling off the rock wall.

This is what the trail looks like going up and down the wall face. Sticks are used to secure the rocks into place on the trail. It takes about one hour to go up or down the trail which is the only way out of the valley. People have slowly moved back into the village by 1984.

Near the top of the cliff are graves. These are not marked and are randomly located thought-out the area. Most were located near or at the top of the cliff. There is also a pulley system located at the top for using a rope to help with moving goods and provisions up and down the cliff.

Bones are clearly visible within these caves in the cliff face. Rocks were piled up to seal off the graves but most showed evidence of being searched at some point. All skulls had been removed.

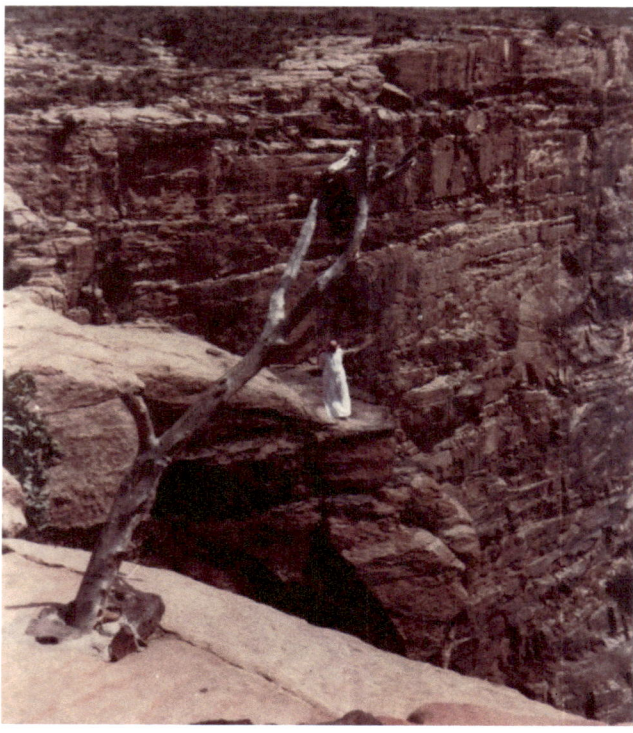

4 ROAD TO THE RED SEA

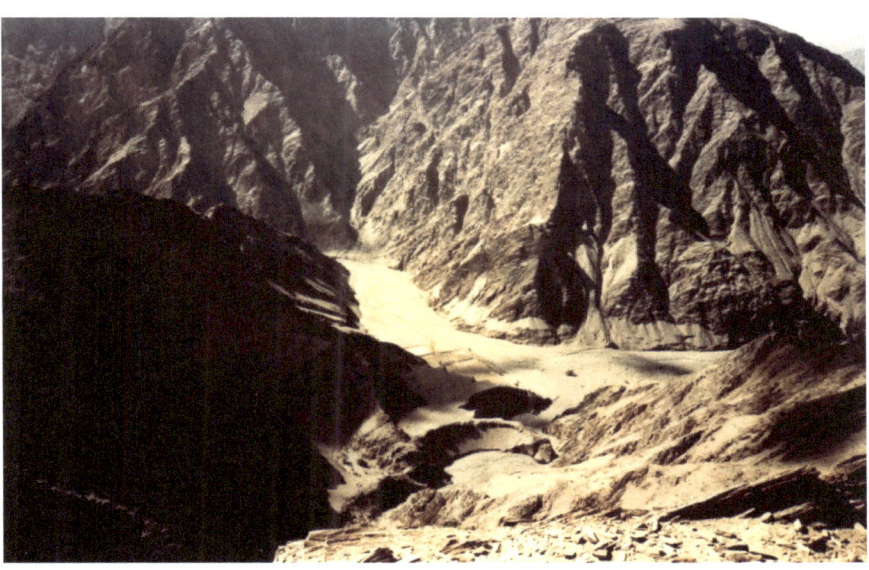

There are two roads down to the Red Sea from Abha. Abha is the nearby city to Khamis Mushayt. One road take about a hour and half to make the journey but it is the old road which has no guard rails and is not paved. If it should rain, your car can be washed off the cliff. Because this has occurred often, a new paved road was built. This new road takes about two and a half hours to navigate. In my many travels to the Red Sea I never took the old road. I regret this, as the road less traveled, may have provided an expanded adventure.

Even though most of the road was paved, there was a long bottom section that had a problem. The first good rain took out most of the road and everyone just went back to the old road bed.

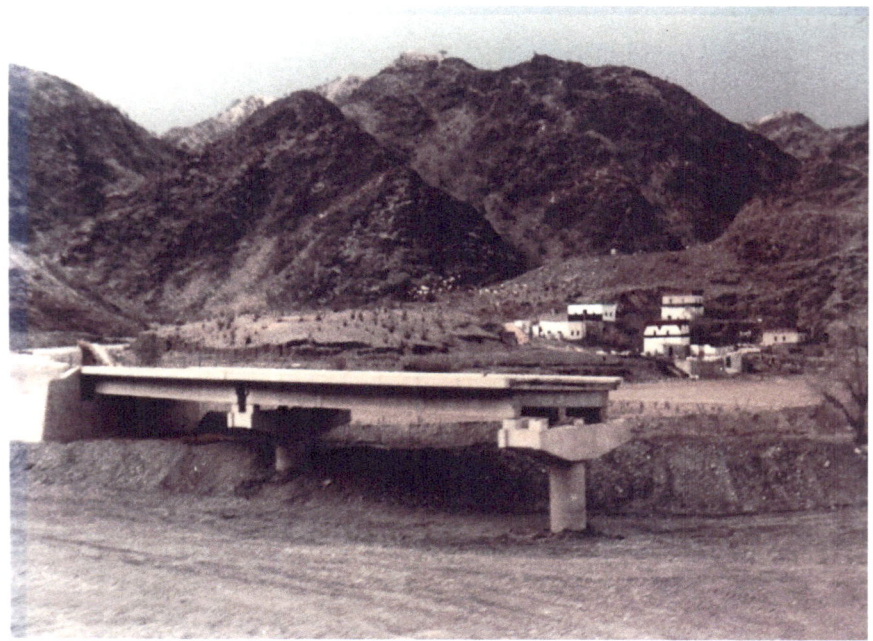

Khamis Mushayt 1984

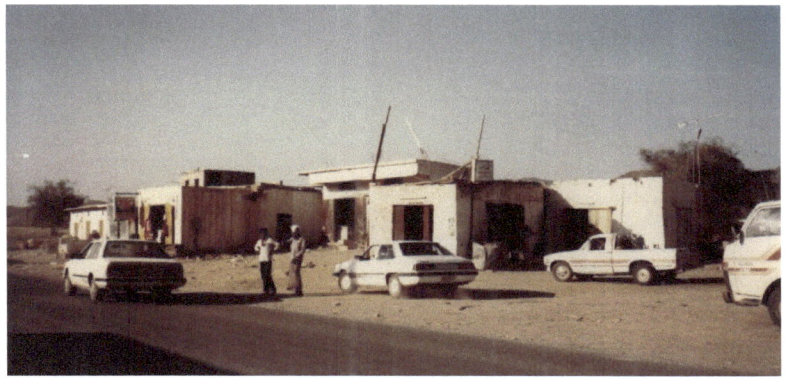

A small town located along the way. Road signs were in English so travel was easy.

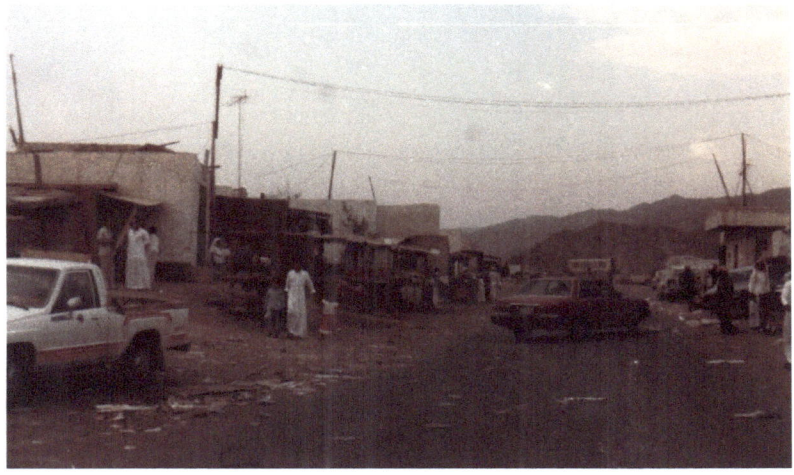

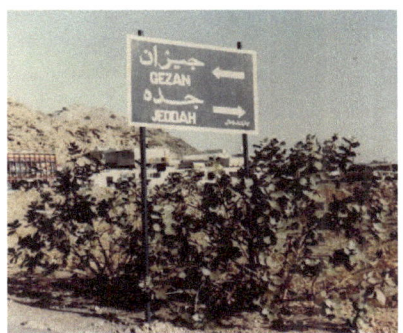

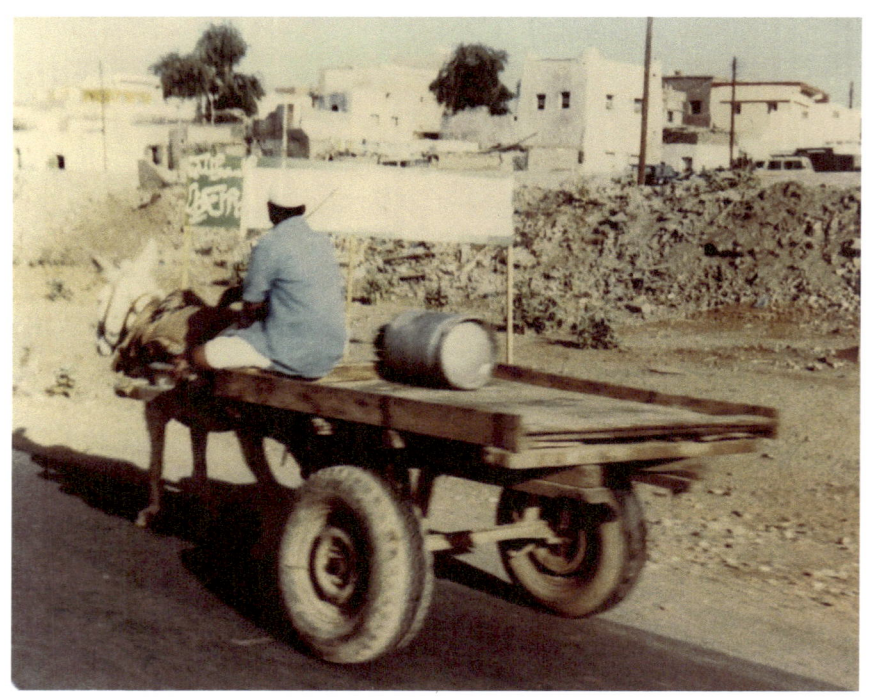

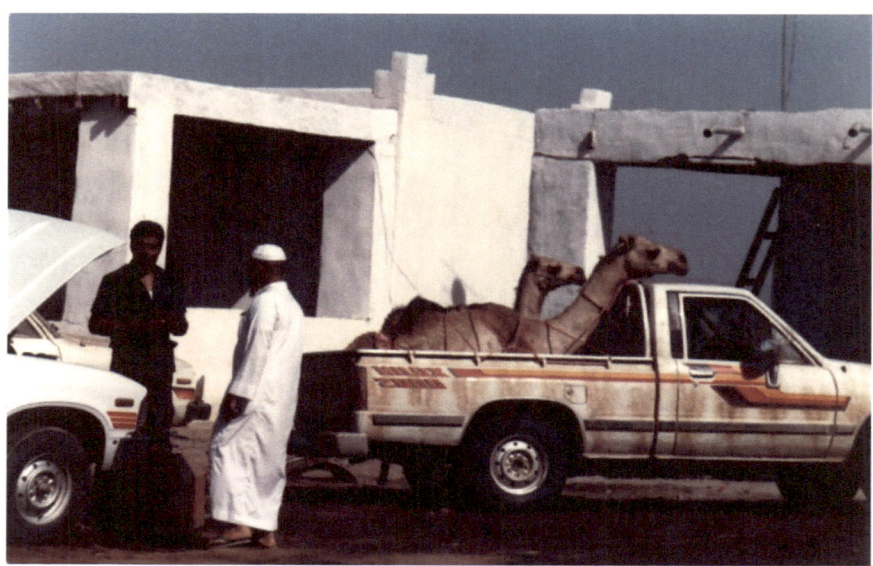

Khamis Mushayt 1984

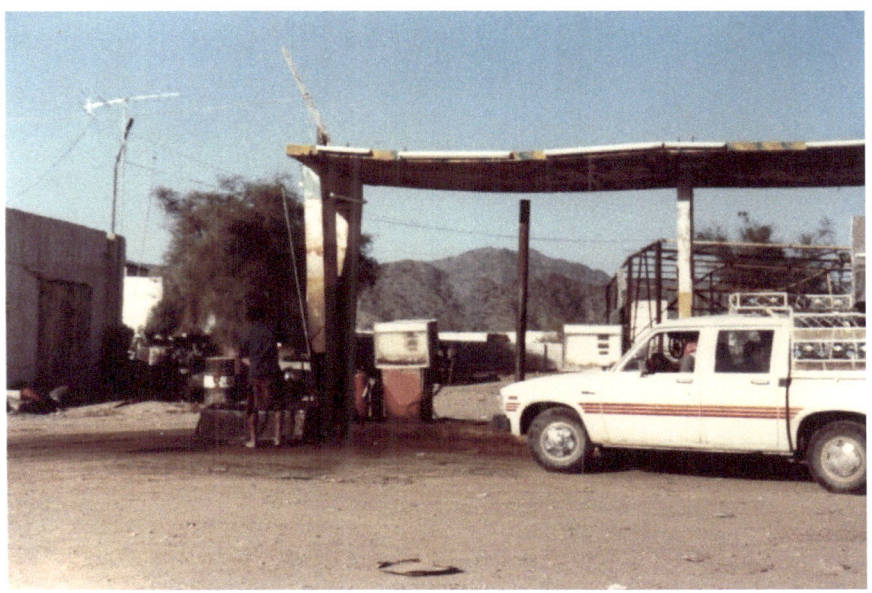

Above is a local gas station and below is the mechanical shop as the truck owner was waiting to get his tire fixed.

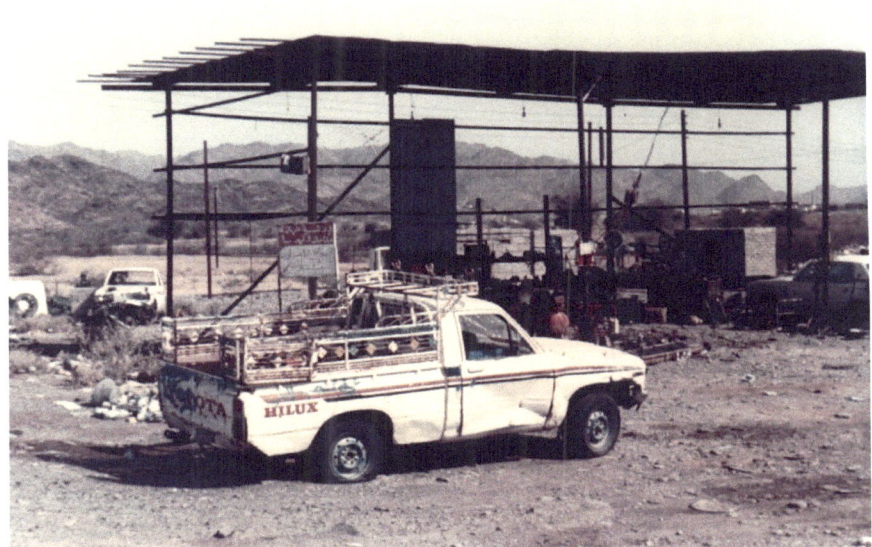

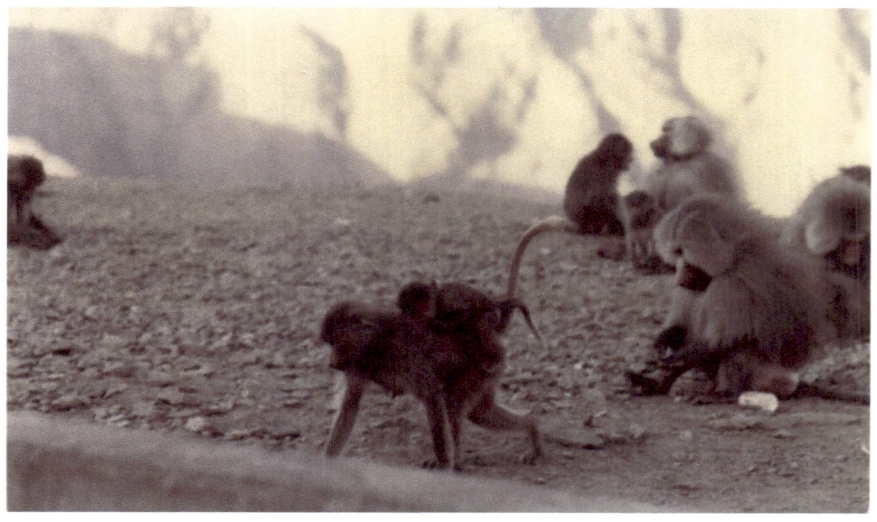

Friends along the way

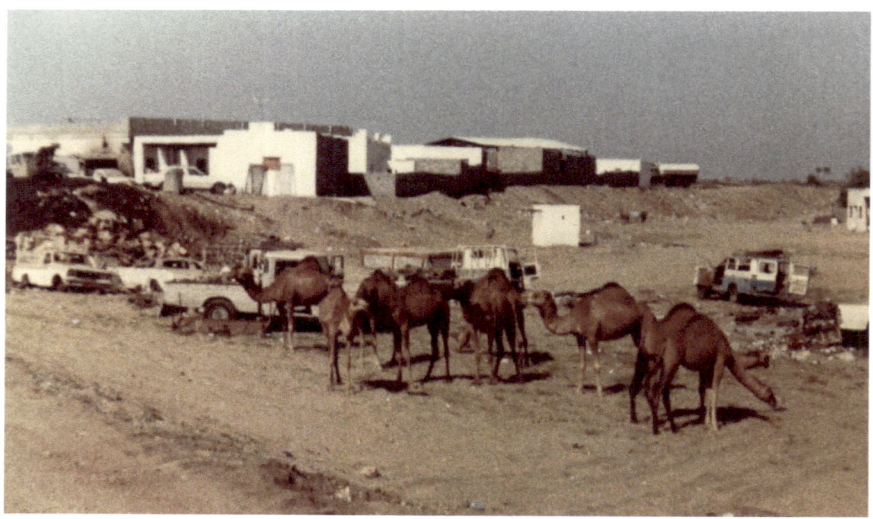

Khamis Mushayt 1984

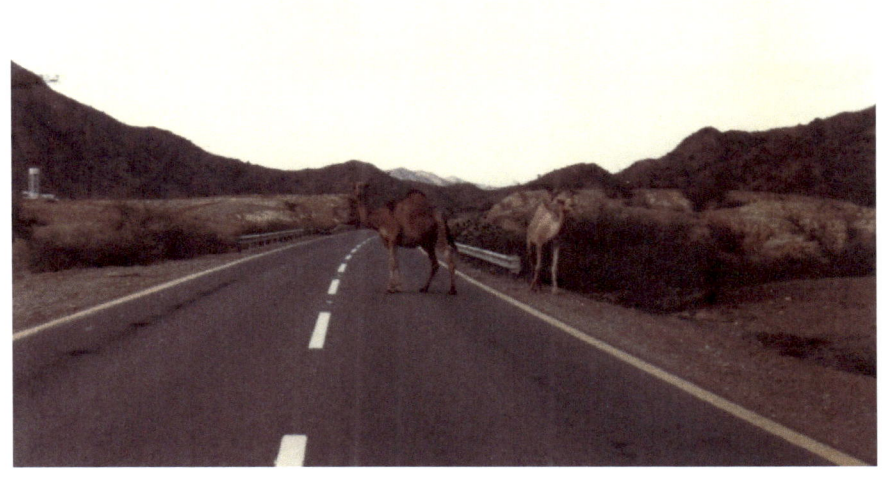

Road hazard, if you hit one of these, the body will come through the windshield due to the long legs. Not a good thing.

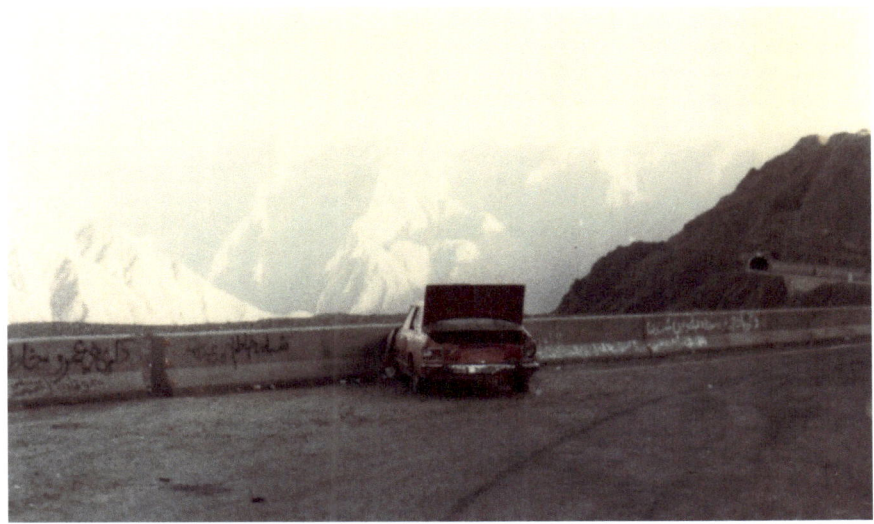

Not uncommon to see a car left in place after an accident. You just go get another car I guess. This one was in place for the entire year I traveled pass it. It was near the start of the trip down.

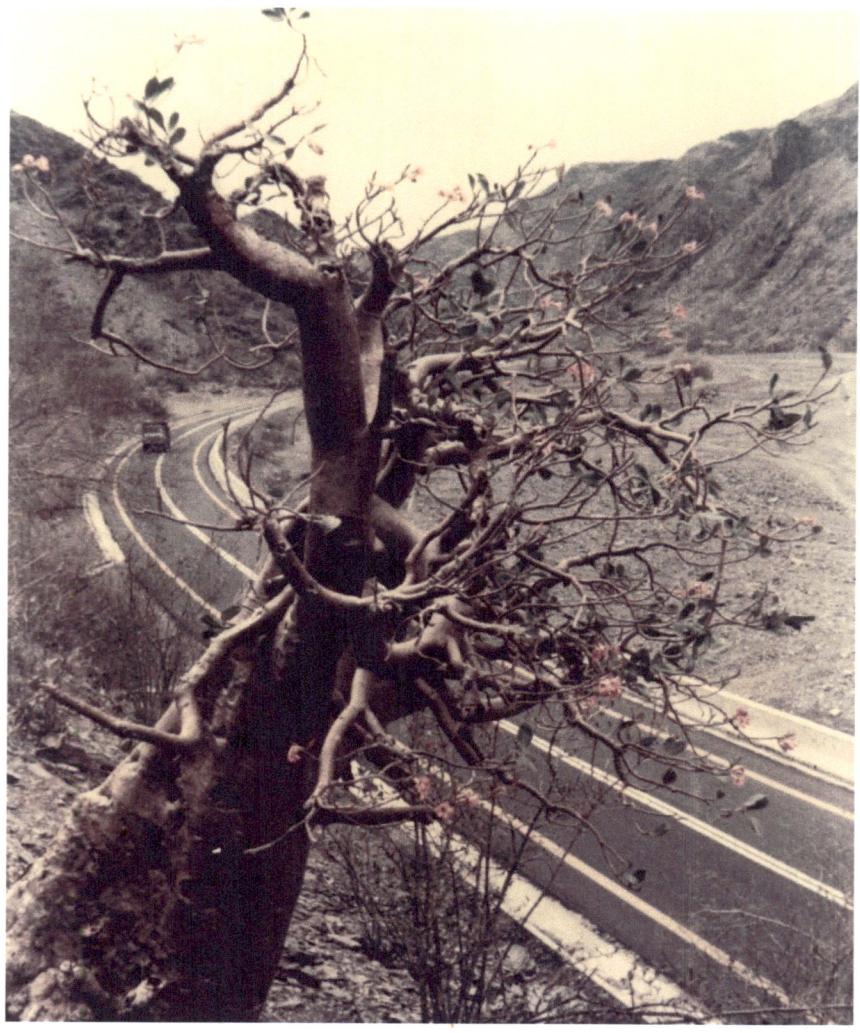

A rare tree for the area. I was told it only grew in that region and was called a elephant tree. It has small green leaves and tiny pink flowers.

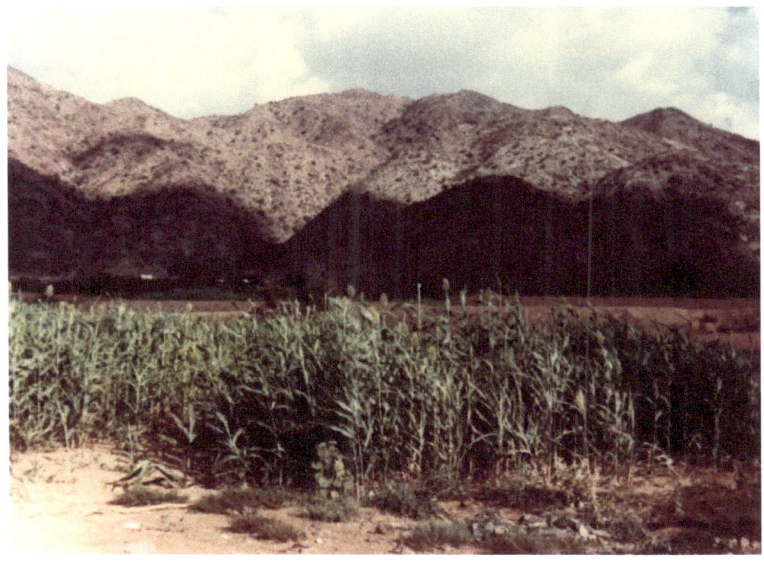

This is the small family owned field of grain I mentioned in the beginning of this book. You take the grain in to be milled. The mill is the picture below.

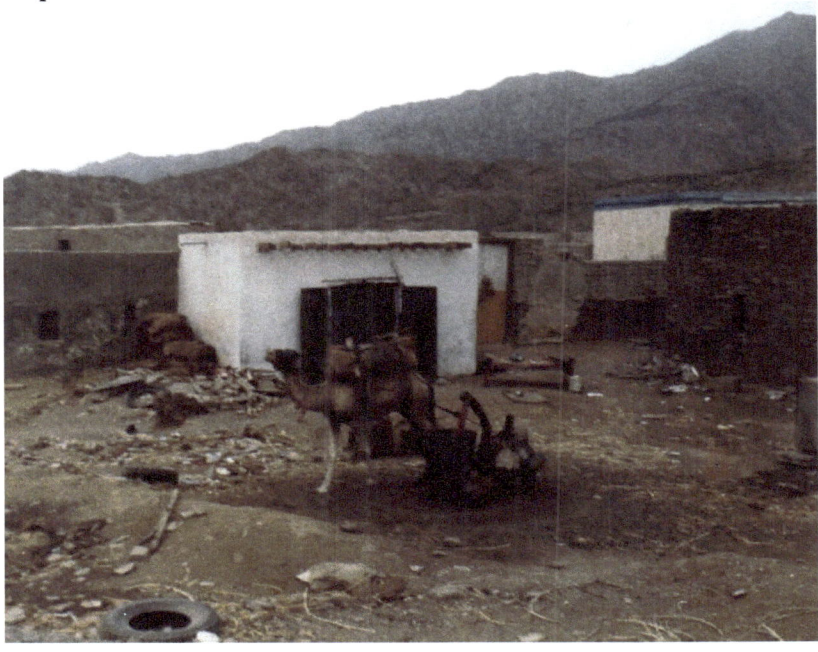

5 TURKISH FORT

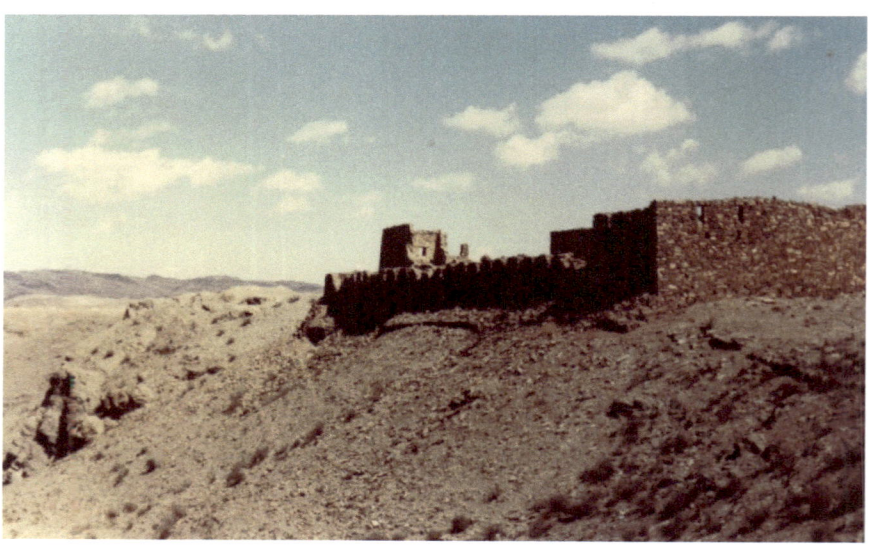

The Turkish Fort as it was known, is located about 15 kilometers north of Abha. It faces west towards the Red Sea and the deep canyon up to Khamis Mushayt. North of the fort are where the graves are located. There is no road out to the fort and the only traffic we heard of was a French group went out there two years earlier. White quarts rock was used in its construction for a decretive effect.

Khamis Mushayt 1984

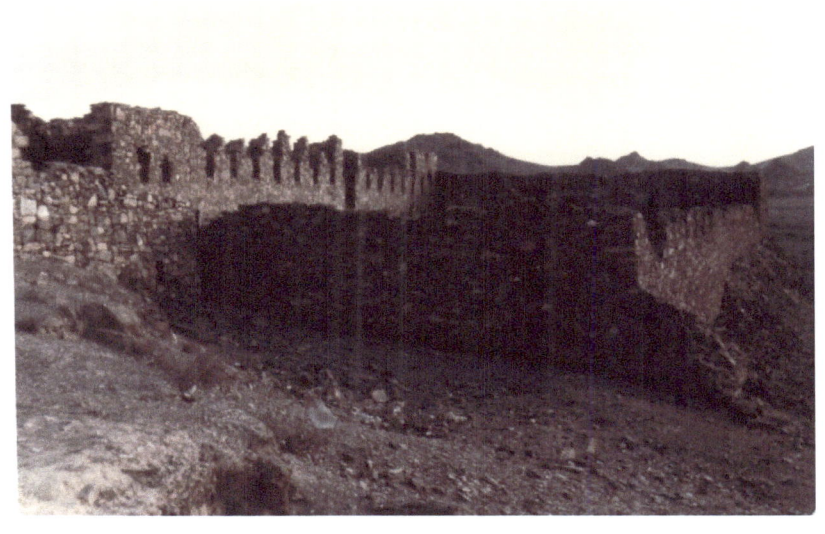

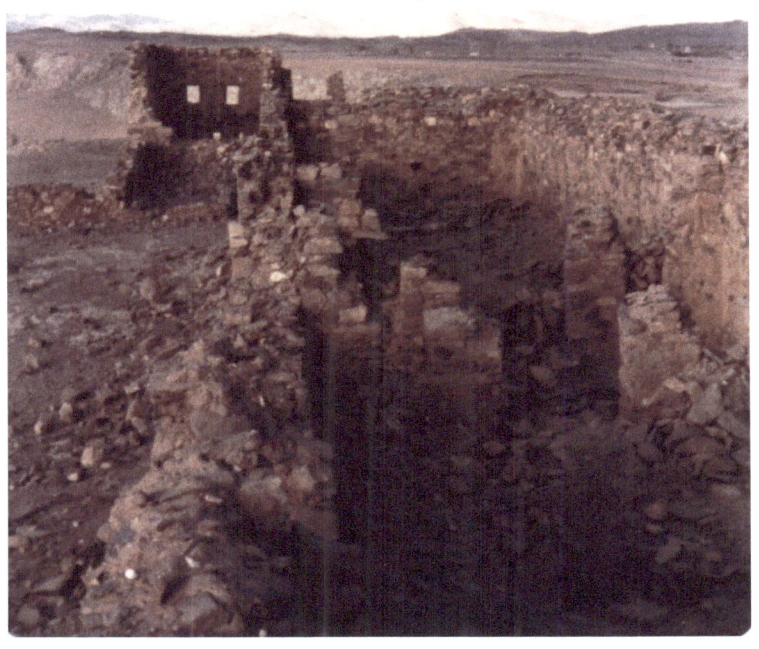

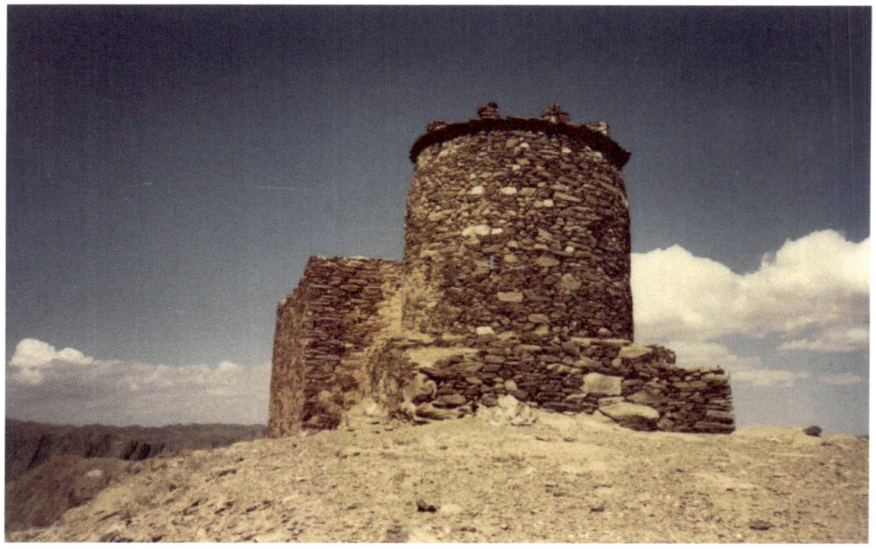

This guard tower contained something of great interest for me. Along with many American World War II rifle brass dated from the war, I found the below carving.

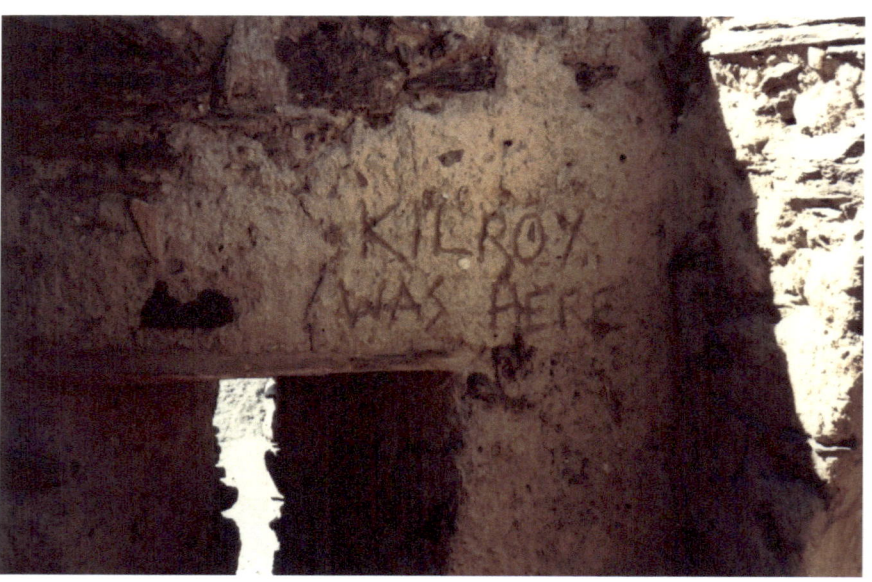

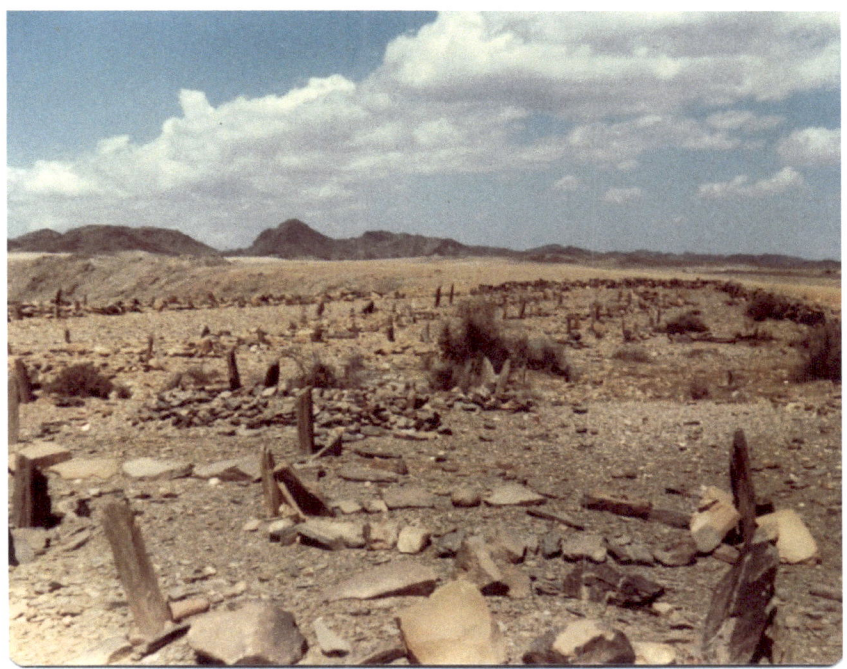

The graves of the unknown

Fort is in the distant to the left, graves to the right, our tracks in the middle of the photo.

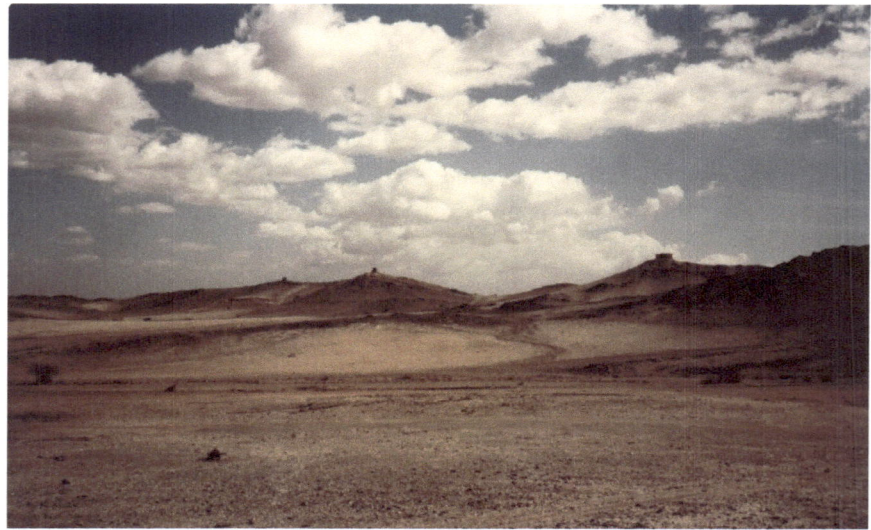

This is the view from the fort. You can see the guard towers in the distance.

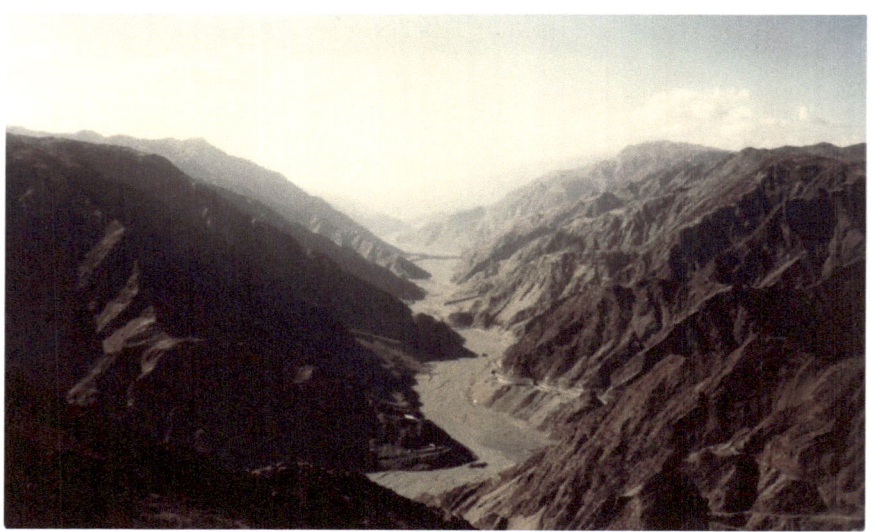

This is the view from the fort front side facing towards the Red Sea.

6 AL SOUDA AND NAJRAN

Al Souda and Najran are located south of Abha. Al Souda is a national park with a small build up area for sightseeing. This area goes down to the Yemen border which was North Yemen at the time. It has since been unified into one country. This is a three hour drive from Khamis Mushayt down to Najran. These pictures were taken along the route.

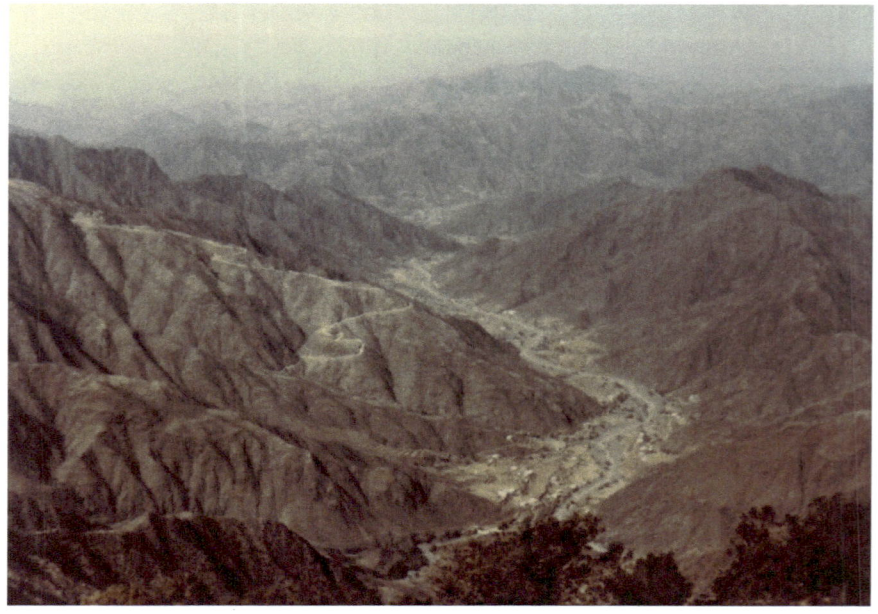

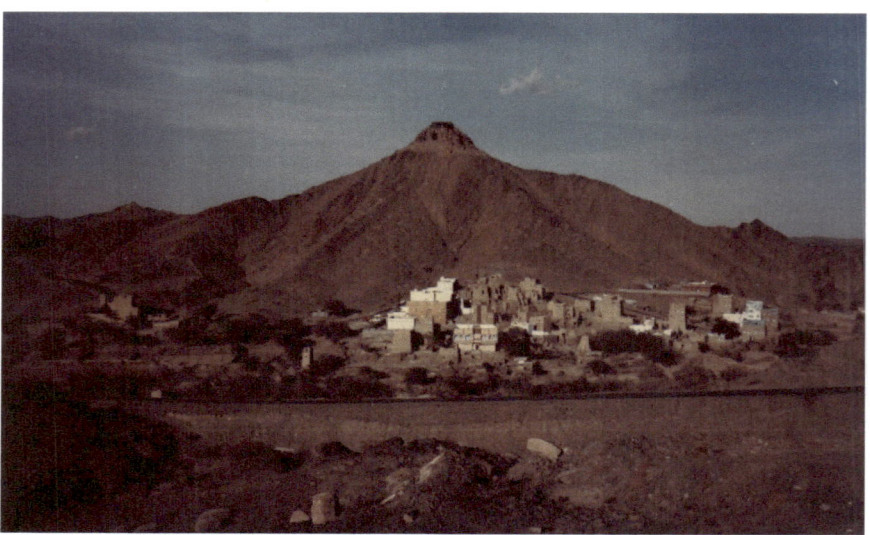

This is a classic picture of how villages were located and protected. Notice the guard tower at the top of the hill.

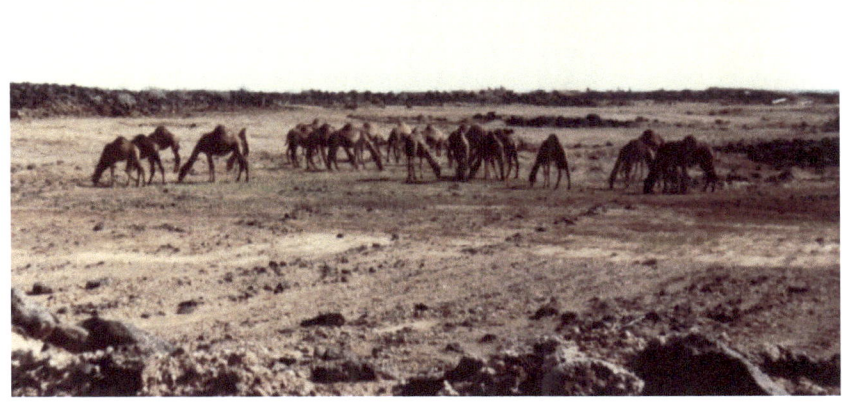

Camels come in three colors, white black, and brown. White ones are used for racing, black for food and milk, and brown for transportation.

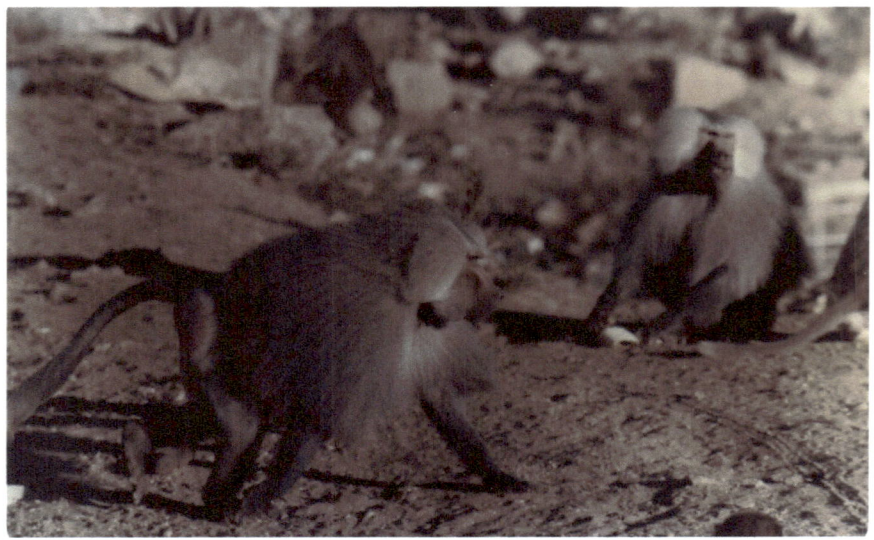

Baboons are everywhere around the region. They might appear cute and harmless paying little attention as I take a few pictures. I assure you they are wild animals and will behave as such when you get too close or if food is involved. They have large teeth and have no fear of humans.

Khamis Mushayt 1984

7 THE PALACE

The palace and the Al Mahallah sports complex is located between Khamis Mushayt and Abha.

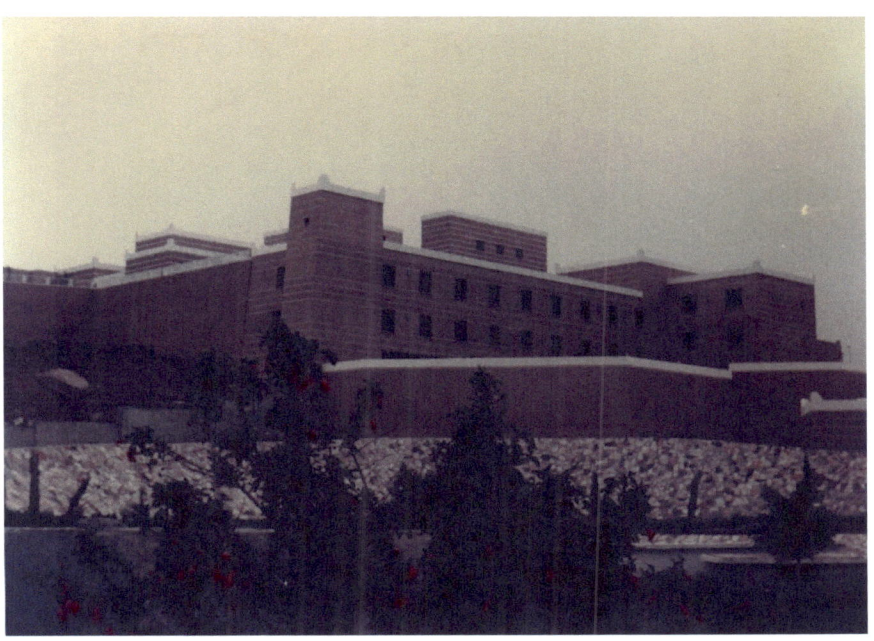

It was so funny, had not seen grass in a year. It was like seeing it for the first time. Even had to touch it to make sure it was real.

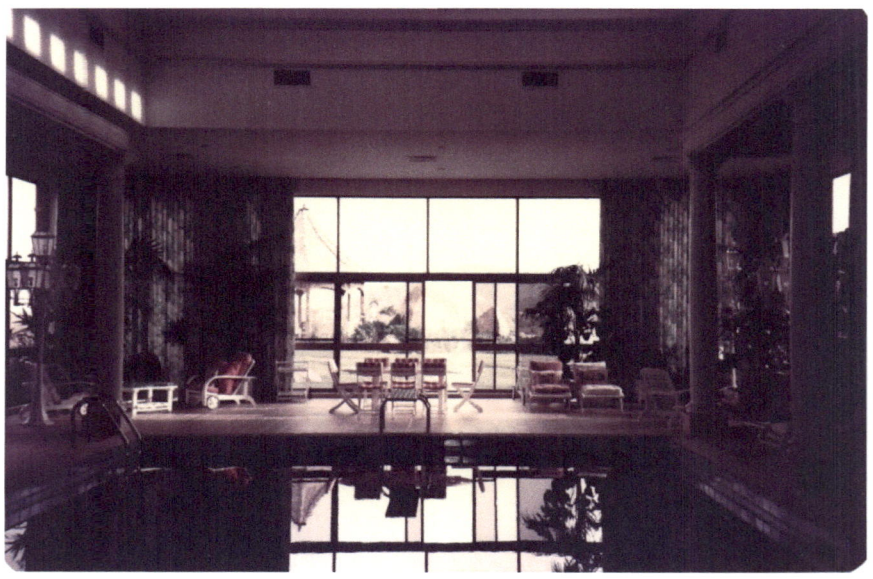

Khamis Mushayt 1984

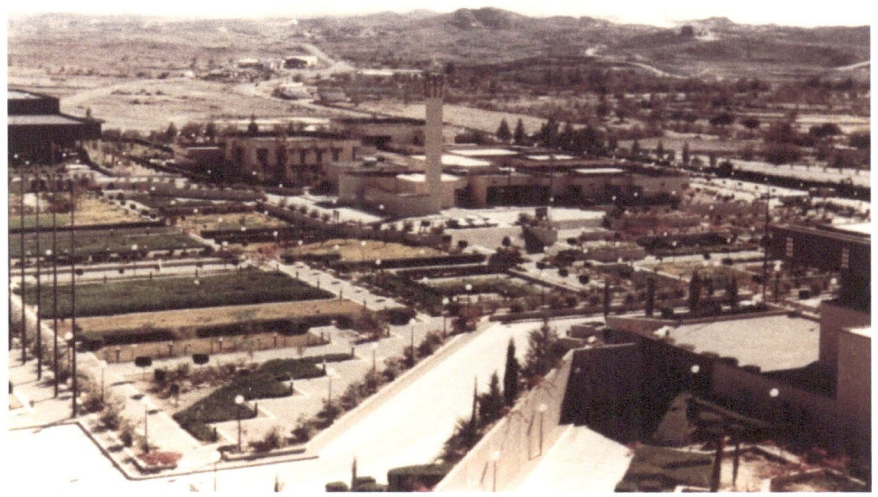

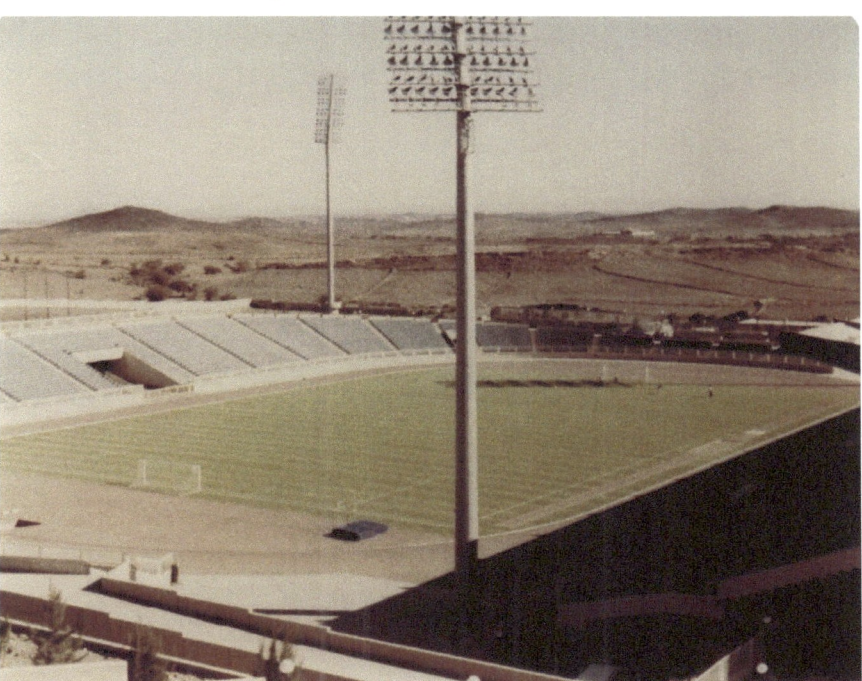

The sports complex is located just north of the palace.

ABOUT THE AUTHOR

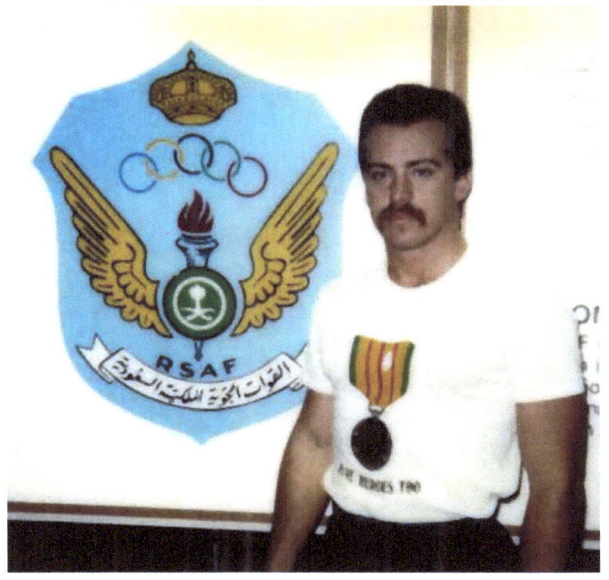

The above picture was taken during this project.

Active as a Black Belt founder of American Martial Arts, served over a dozen honorable years of military police service to America, and completed a new military based novel, boredom is not part of his lexicon. With more than 20 years of diverse medical experience, Dr. Willer worked for ECPI University as a medical instructor. He holds a doctorate in Healthcare Administration from Warren National University, masters from Wayne State College in education, and is a certified cardiovascular technologist. He is currently working for Precision Dynamics Group as a Private Investigator Associate.

www.ingramcontent.com/pod-product-compliance
Lightning Source LLC
Chambersburg PA
CBHW041110180526
45172CB00001B/190